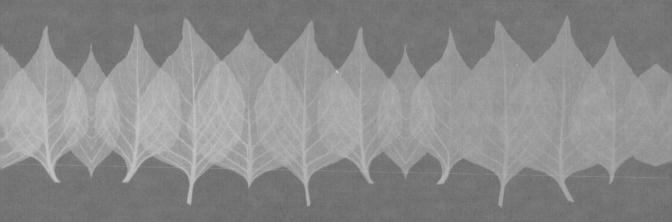

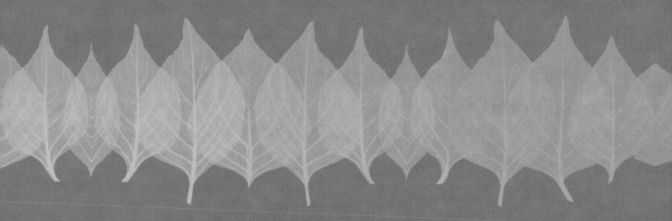

Published by Ronnie Sellers Productions, Inc.

Copyright © 2006 Ronnie Sellers Productions, Inc.
Photography copyright © 2006 Steven N. Meyers
All rights reserved.

Introduction by Ronnie Sellers

Edited by: Robin Haywood
Managing Editor Mary Baldwin
Assistant Production Editor: Charlotte Smith
Colorists: Kathy Fisher, Brian Currier, Wendy Crowell, Nicole Cyr

ISBN-13: 978-1-56906-973-8
ISBN-10: 1-56906-973-5

Text credits appear on page 96.

Ronnie Sellers Productions, Inc.
81 West Commericial Street • Portland, Maine 04104
For ordering information:
Toll free: 800-MAKEFUN (800-625-3386)
Fax: (207) 772-6814
Visit our Web site: www.makefun.com
E-mail: rsp@rsvp.com

Printed and bound in China.

flower spirits

the beauty that blooms within
photography by steven n. meyers

Introduction

Flowers and other flora have always been among the favorite subjects of artists from all disciplines. Whether we are conscious of it or not, the fact that we have been exposed to so many paintings, photographs, poems, and written descriptions of flowers causes us to have expectations about what any work of art on the subject of flowers might reveal.

A painting might show the intensity or variety of a flower's colors. A poem may uncover the symbolic significance of a flower's perennial ability to resurrect itself. A photograph might highlight the elegant and mysterious shapes, shades, and textures of its blossoms. A piece of prose might hint at the nuances of its fragrance.

What is most unique, perhaps, about Steven Meyers's radiographs of flowers is that they expose new things about their subjects, things that are outside of our realm of expectations. What we see when we view his work are the amorphous and incredibly exquisite elements that give flowers their structure.

Other artists help us to appreciate the beauty of a flower's shape, but Meyers offers us the opportunity to glimpse, and marvel at, the gossamer strands, stems, and stamens that make that shape possible.

Meyers's expertly crafted compositions emphasize the extent to which the structural elements his medium reveals are part of a flower's gracefulness and beauty. It is difficult to view his work without feeling as though you are seeing what flowers really look like for the first time, seeing their spirits, if you will, and the ethereal beauty that lies within them.

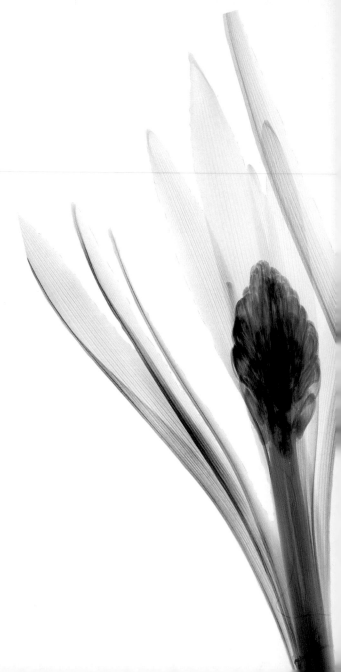

If I had but two loaves
of bread, I would sell one
and buy hyacinths, for
they would feed my soul.

Koran

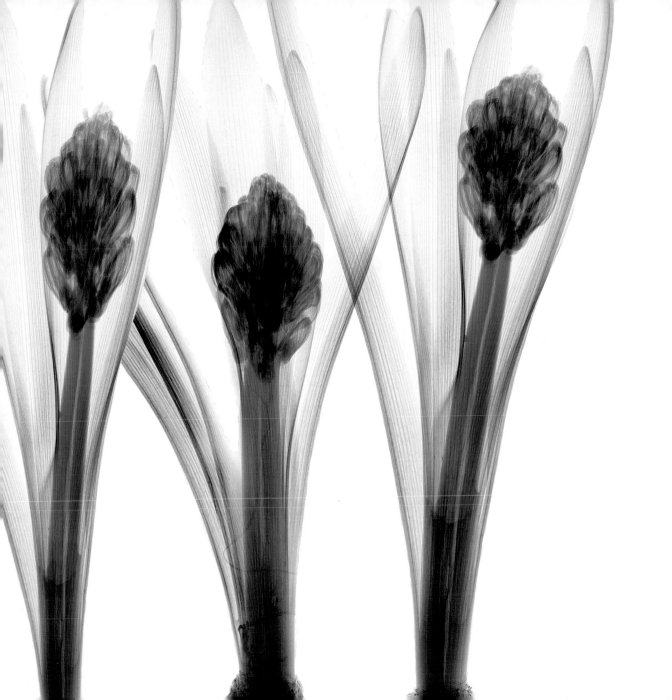

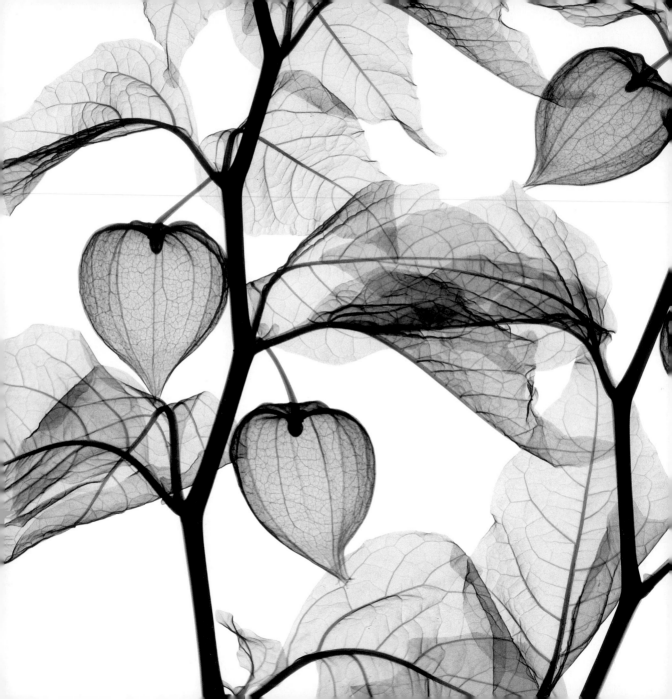

Flowers and plants are silent presences;

they nourish every sense except the ear.

May Sarton

If we could see the miracle of a single flower clearly, our whole life would change.

Gautama Siddharta

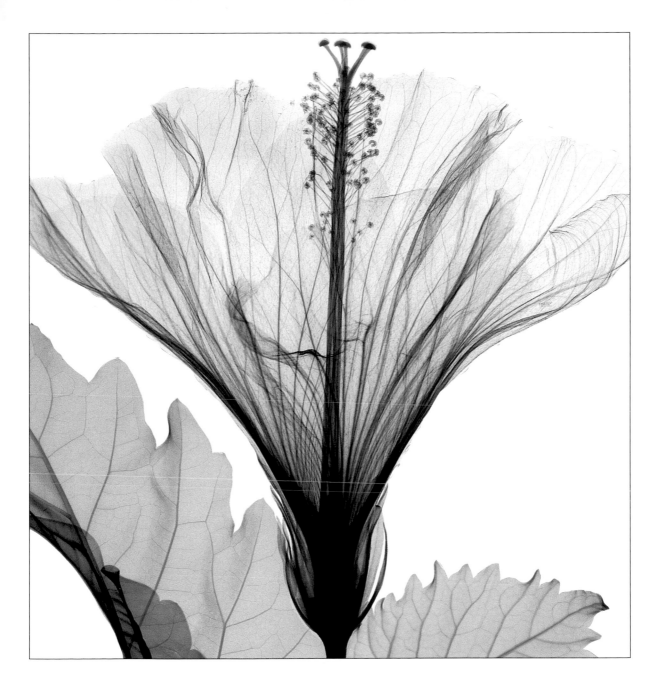

A flower's fragrance declares
to all the world that it is fertile,
available, and desirable, its sex organs
oozing with nectar. Its smell reminds us
in vestigial ways of fertility, vigor, life-force,
all the optimism, expectancy, and passionate
bloom of youth. We inhale its ardent aroma
and, no matter what our ages, we feel
young and nubile in a world
aflame with desire.

Diane Ackerman

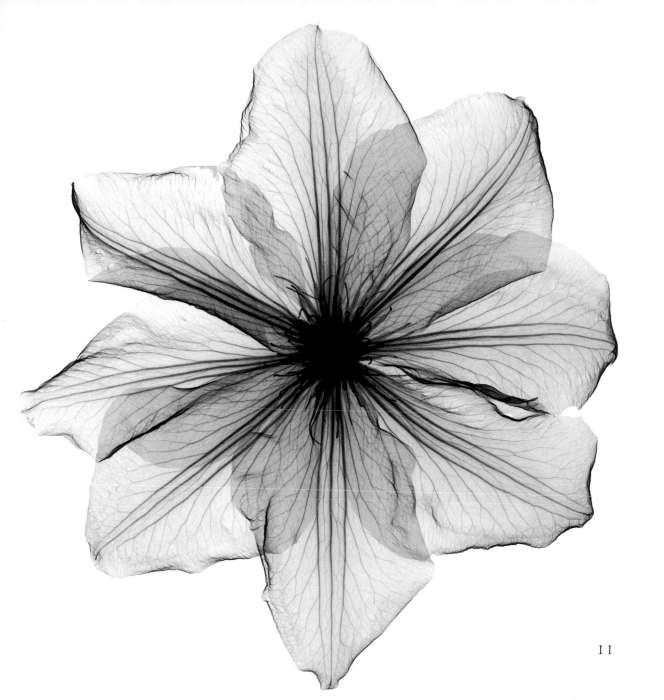

11

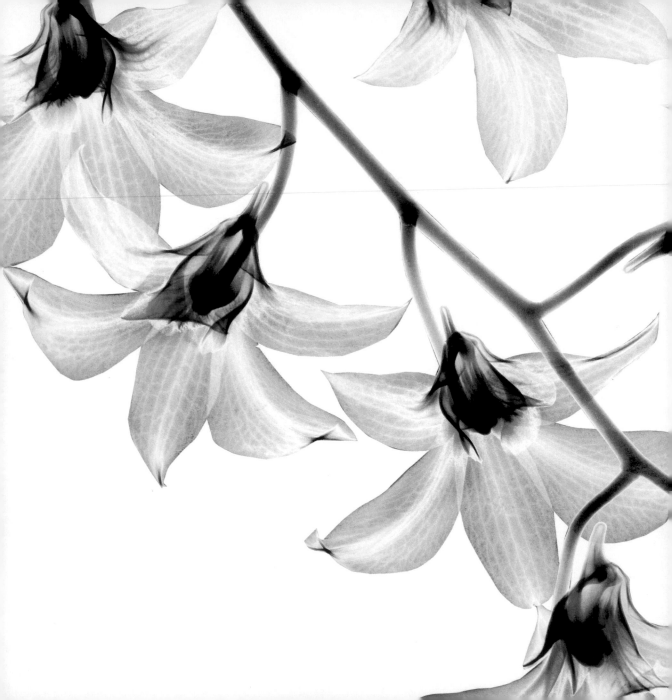

"I love to smell flowers in the dark,"

she said. "You get hold of their soul then."

Lucy Maud Montgomery

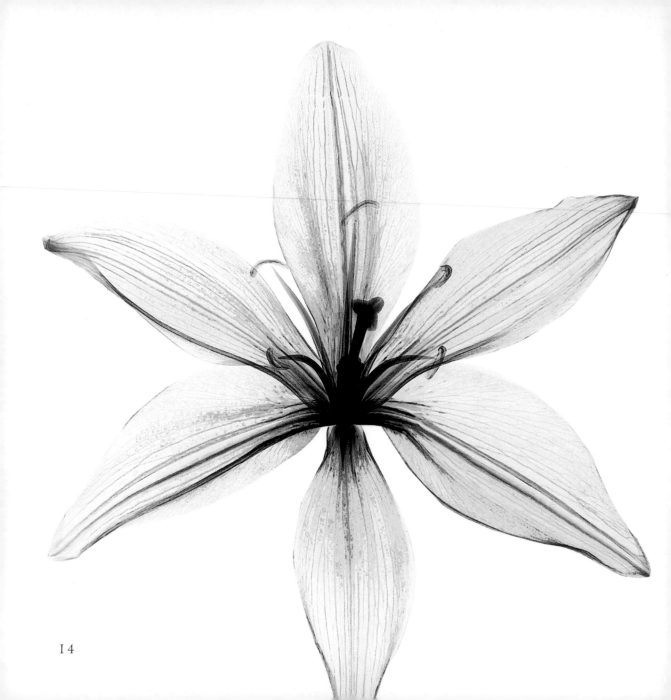

14

We soon after saw a splendid yellow lily (*Lilium canadense*) by the shore, which I plucked. It was six feet high, and had twelve flowers, in two whorls, forming a pyramid, such as I have seen in Concord. We afterward saw many more thus tall along this stream, and also still more numerous on the East Branch, and, on the latter, one which I thought approached yet nearer to the *Lilium superbum.* The Indian asked what we called it, and told us that the "loots" (roots) were good for soup, that is, to cook with meat, to thicken it, taking the place of flour. They get them in the fall. I dug some, and found a mass of bulbs pretty deep in the earth, two inches in diameter, looking, and even tasting, somewhat like raw green corn on the ear.

Henry David Thoreau

The richness I achieve comes from Nature, the source of my inspiration.

Claude Monet

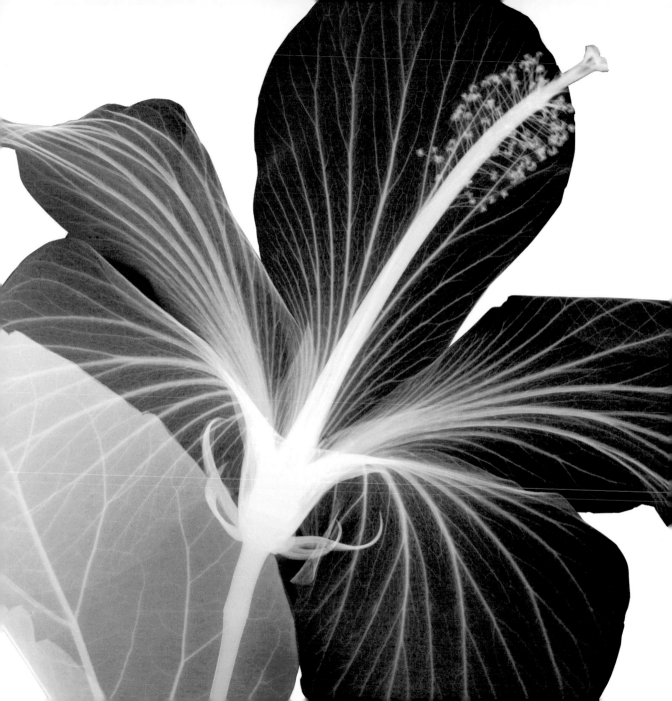

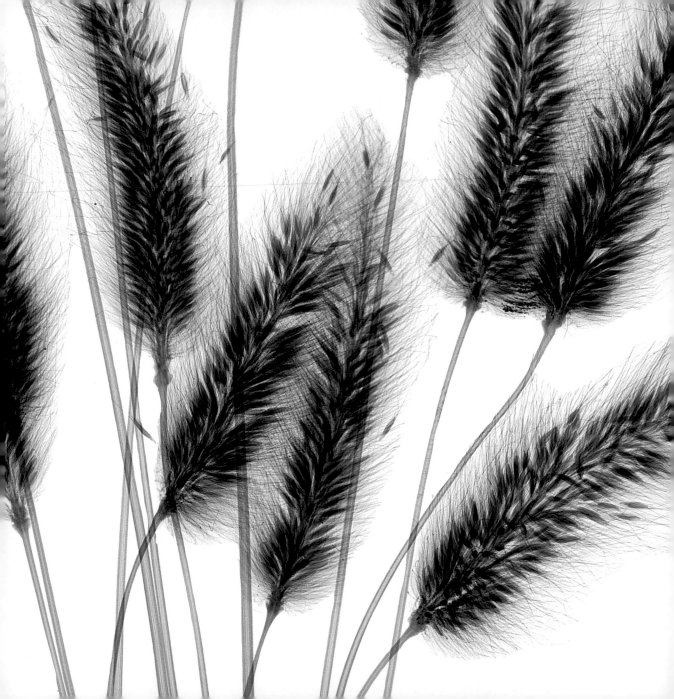

A weed
is no more
than a flower
in disguise.

James Russell Lowell

But it is the beauty of seed pods that strikes me just now. The rushed blooming of flowers is over, and colour of flower has given way to the seed pod form. It is so wrong to think of the beauty of flowers only when they are at their height of blooming; bud and half developed flower, fading blossom and seed pod are as lovely, and often more interesting.

Clare Leighton

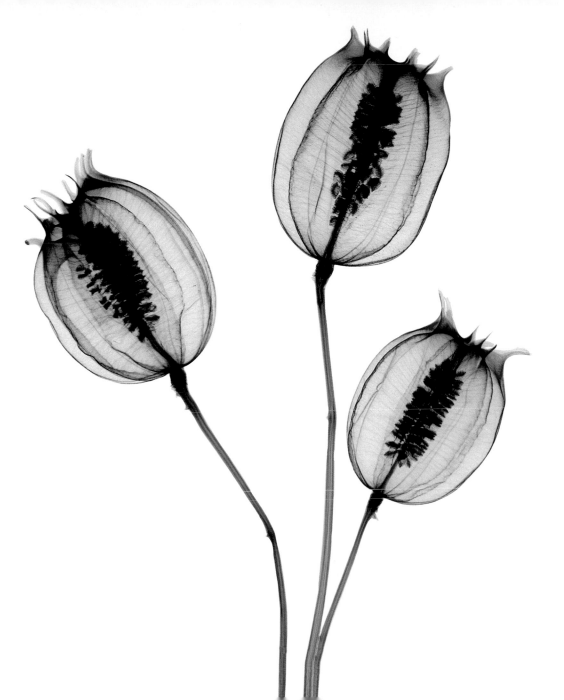

21

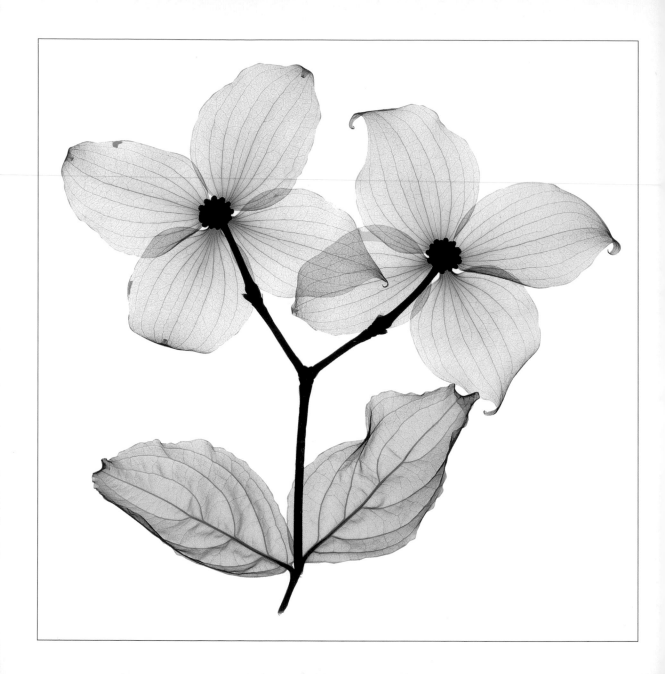

In the hope of reaching the moon,

men fail to see the flowers

that blossom at their feet.

Albert Schweitzer

If all flowers wanted to be roses, Nature would lose her springtime beauty, and the fields would no longer be decked out with little wildflowers.

Saint Therese of Lisieux

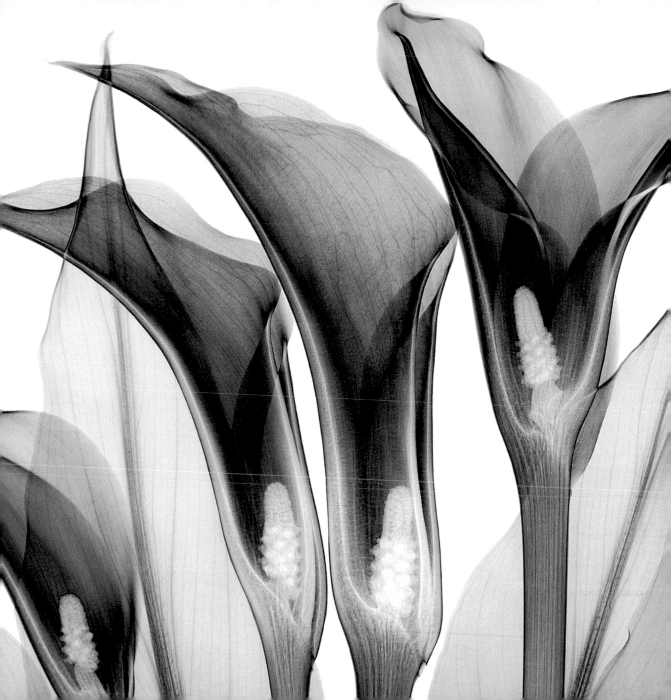

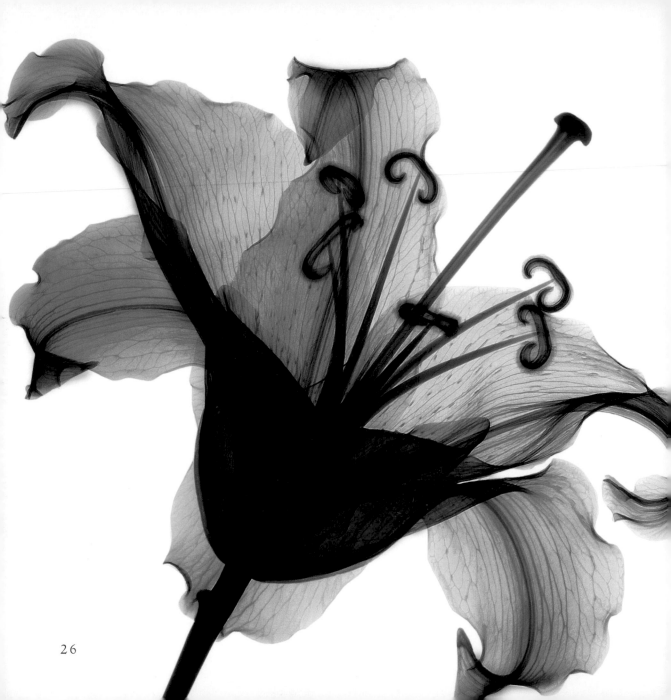

Lily

Sincerity and majesty. Purity and virginity. Symbol of motherhood. Peace.

According to the Roman myth, when Juno, the queen of the gods and the goddess of marriage, was nursing her son Hercules, excess milk fell from the sky. Part of it stayed in the heavens, creating the Milky Way, and part of it fell to Earth, creating the lilies. In Rome, lilies were known as Rosa junonis or Juno's rose.

Hana No Monogatari

When you take a flower in your hand and really look at it, it's your world for the moment. I want to give that world to someone else. Most people in the city rush around so, they have not time to look at a flower. I want them to see it whether they want to or not.

<div align="right">Georgia O'Keeffe</div>

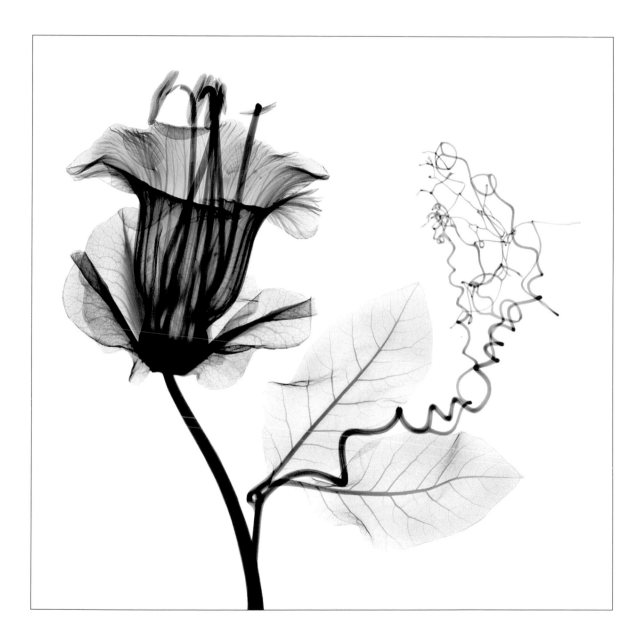

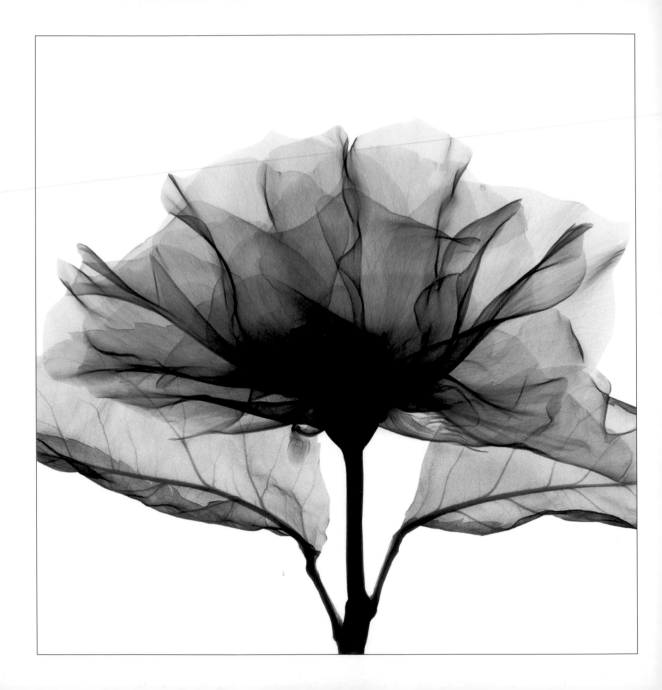

You love the roses — so do I!
I wish the sky would rain down roses,
As they rain from off the shaken bush.
Why will it not? Then all the valley would
Be pink and white and soft to tread on.
They would fall as light as feathers,
Smelling sweet; and it would be like
Sleeping and like waking, all at once!

George Eliot

Study Nature, love Nature,

stay close to Nature.

It will never fail you.

Frank Lloyd Wright

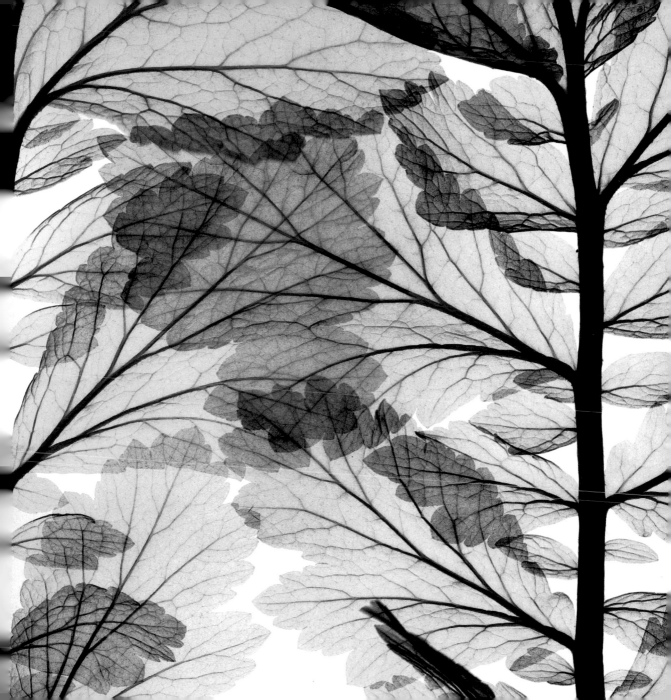

Who can estimate the elevating and refining influences and moral value of flowers with all their graceful forms, bewitching shades and combinations of colors and exquisitely varied perfumes? These silent influences are unconsciously felt even by those who do not appreciate them consciously and thus with better and still better fruits, nuts, grains, vegetables and flowers, will the Earth be transformed, man's thought refined, and turned from the base destructive forces into nobler production. One which will lift him to high planes of action toward the happy day when the Creator of all this beautiful work is more acknowledged and loved, and where man shall offer his brother man, not bullets and bayonets, but richer grains, better fruit, and fairer flowers from the bounty of this Earth.

George Schoener

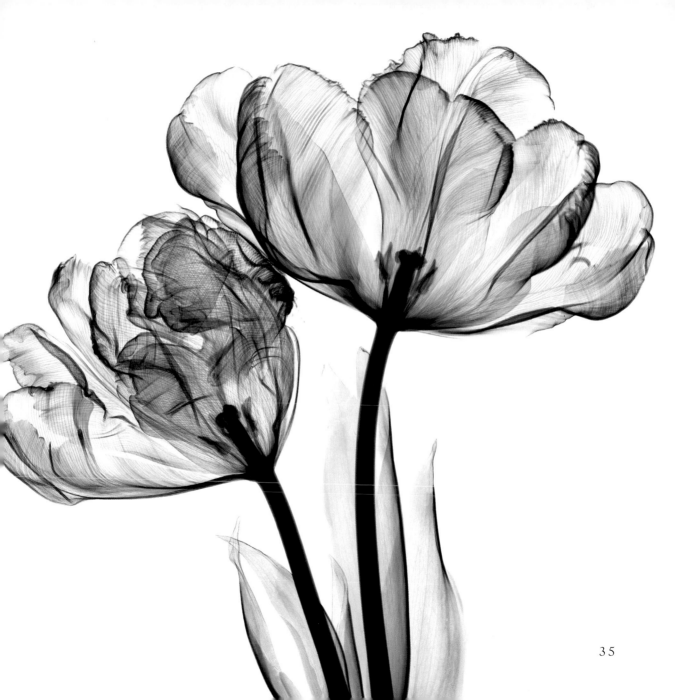

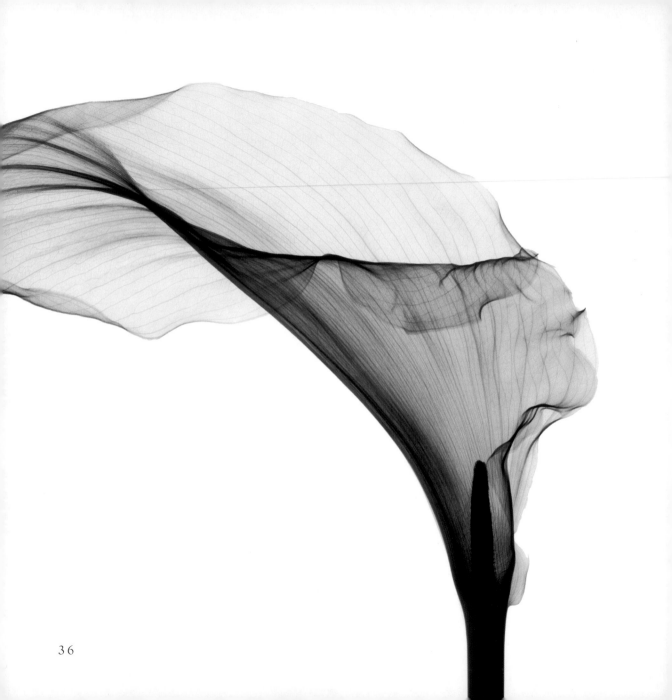

The calla lily is so sensual

With its phallic-like center

Jetting erotically out of its pure white petals

Savannah Skye

Flowers
belong to Fairy-
land: the flowers and the birds
and the butterflies are all that the
world has kept of its golden age — the only
perfectly beautiful things on Earth
— joyous, innocent, half-divine;
useless, say they who are wiser
than God.

<div align="right">Ouida</div>

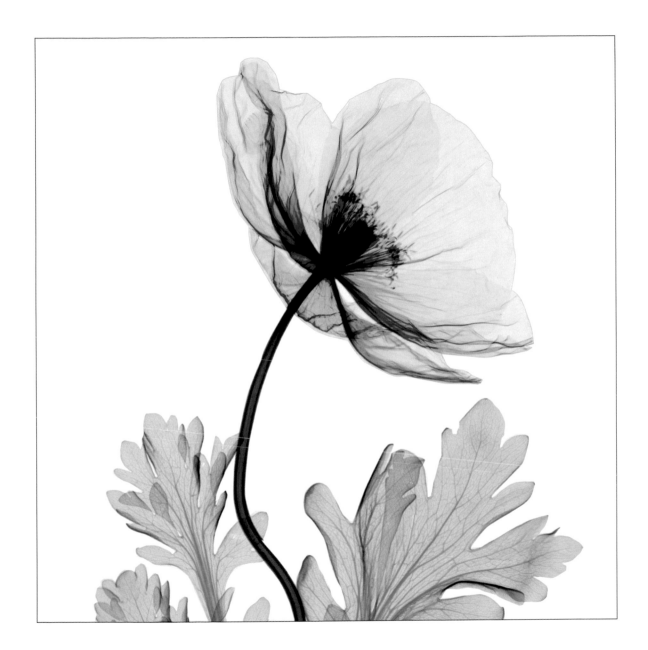

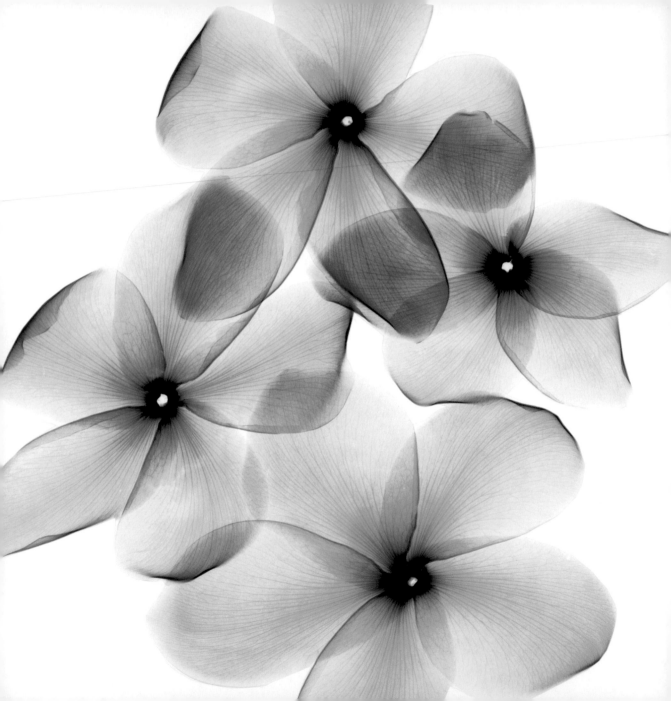

Flowers construct
the most charming geometries:
circles like the sun, ovals, cones,
curlicues and a variety of triangular
eccentricities, that when viewed with
the eye of a magnifying glass seem
a Lilliputian frieze of psychedelic
silhouettes.

Duane Michals

In the 1600s, a language of flowers developed in Constantinople and in the poetry of Persia. Charles II introduced the Persian poetry to Europe, and Lady Mary Wortley Montagu brought the flower language from Turkey to England in 1716. It spread to France and became a handbook of 800 floral messages known as the *Book Le Language des Fleurs.* Lovers exchanged messages as they gave each other selected flowers or bouquets. A full red rose meant beauty. Red and white mean unity. Crocus said "abuse not," while a white rosebud warns that one is too young for love. Yellow roses were for jealousy, yellow iris for passion, filbert for reconciliation, and ivy for marriage.

Valentine's Day Love Traditions

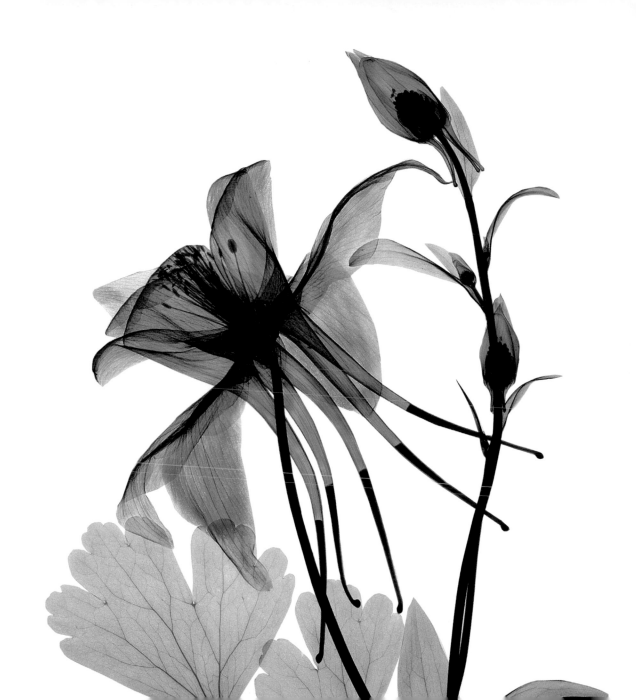

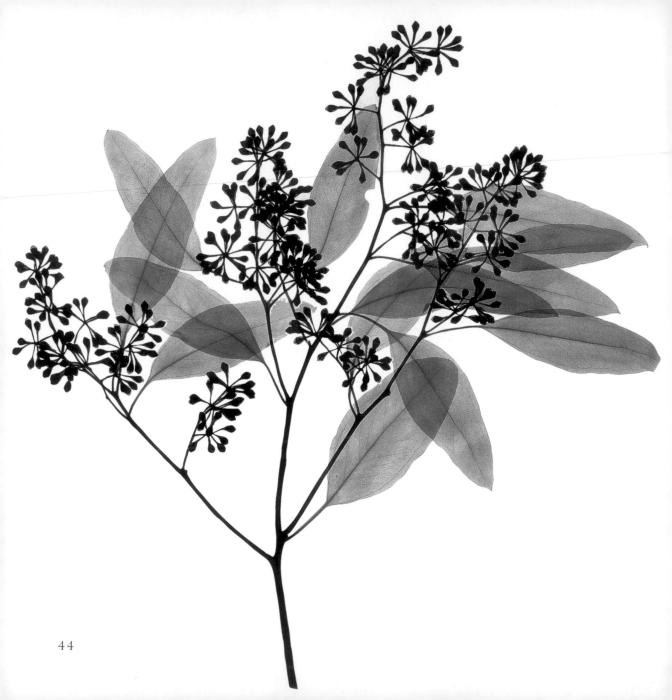

44

The one had leaves of dark green

that beneath were as shining silver,

and from each of its countless flowers

a dew of silver light was ever falling,

and the Earth beneath was dappled

with the shadows of his fluttering leaves.

J. R. R. Tolkien

Cyclamen

I know of no other genus whose plants flower

out-of-doors every day of the year. I know

of no other genus with one or more

species coming into bloom or

growth peaking or going

dormant at every

season.

Nancy Goodwin

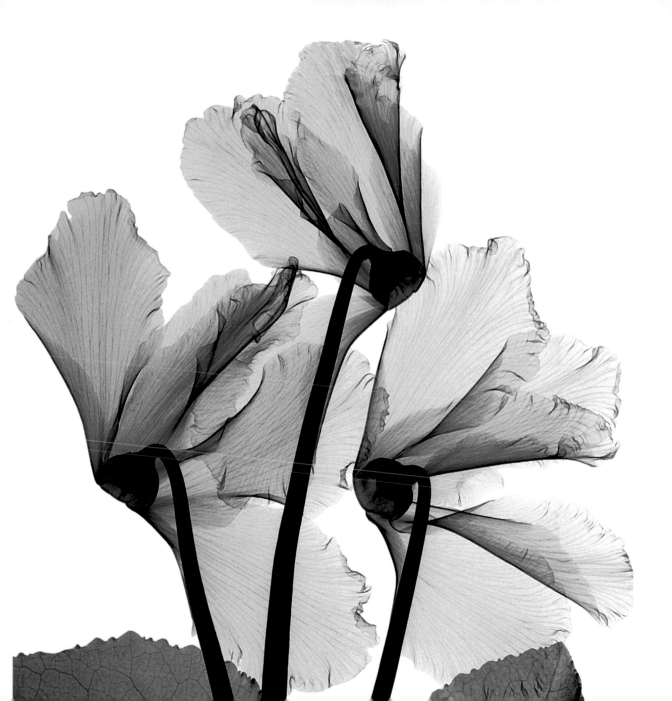

There has fallen a splendid tear
From the passion-flower at the gate.
She is coming, my dove, my dear;
She is coming, my life, my fate;
The red rose cries, 'She is near, she is near;'
And the white rose weeps, 'She is late;'
The larkspur listens, 'I hear, I hear;'
And the lily whispers,
'I wait.'

Alfred Tennyson

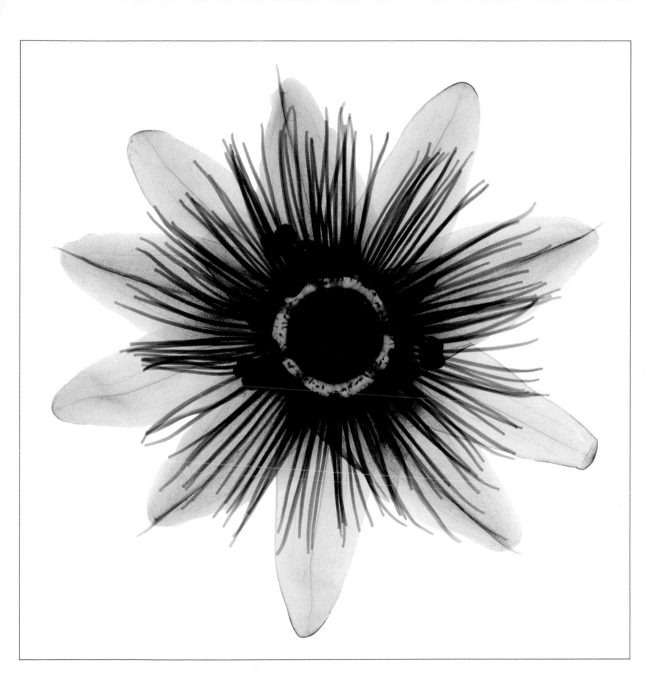

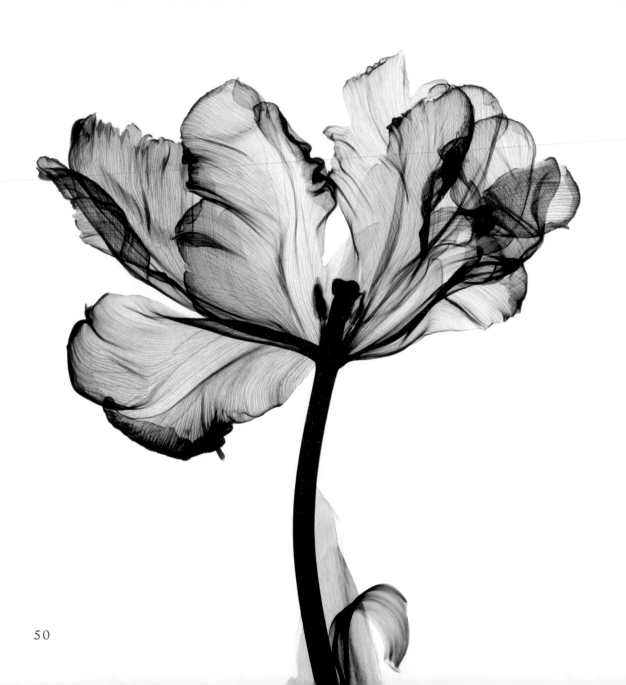

50

There is to me a daintiness about early flowers

that touches me like poetry. They blow out with

such a simple loveliness among the common herbs

of the pastures, and breathe their lives so unobtrusively,

like hearts whose beatings are too gentle for the world.

Nathaniel Parker Willis

The silence of a flower:

a kind of silence that we continually evade,

of which we find only the shadow in dreams.

<div align="right">Lewis Thompson</div>

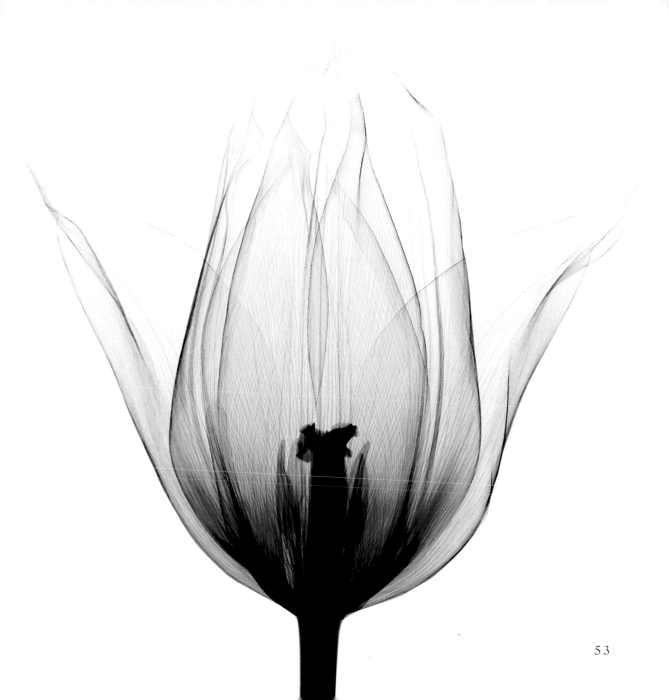

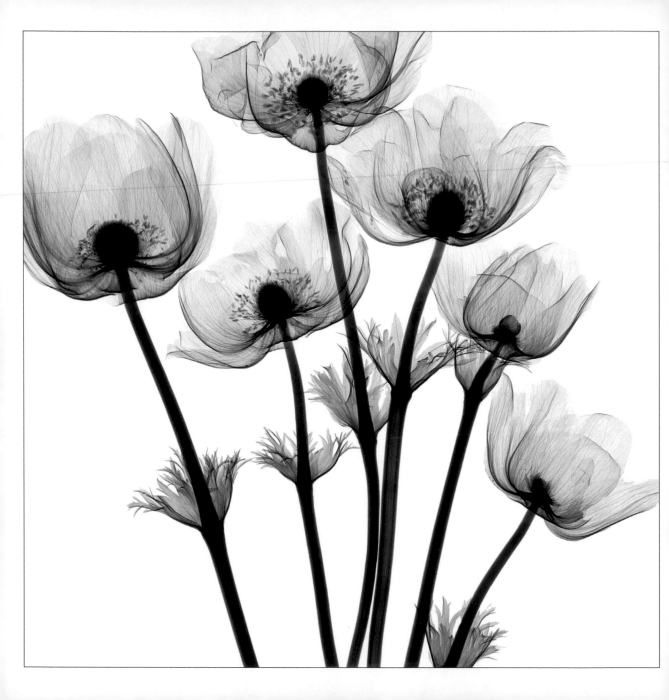

Every rose is an autograph from the hand of the Almighty God on this world about us. He has inscribed His thoughts in these marvelous hieroglyphics that common sense and science have been these many thousand years seeking to understand.

Theodore Parker

Flowers leave some of their fragrance in the hand that bestows them.

<div align="right">Chinese proverb</div>

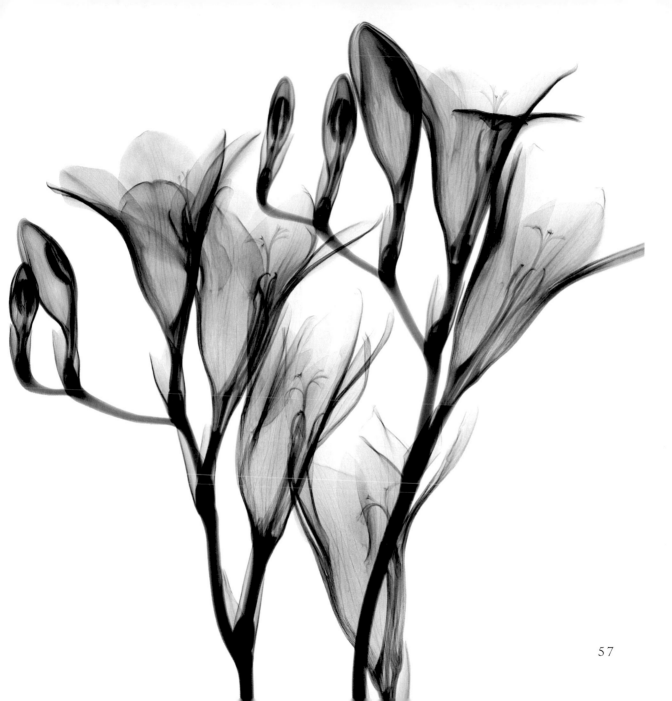

Summer set lip to Earth's bosom bare,
And left the flushed print in a poppy there.

Francis Thompson

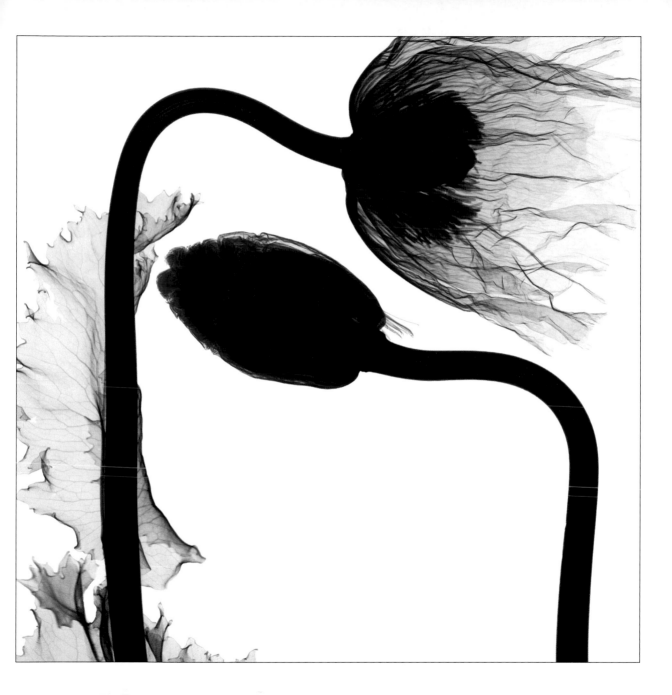

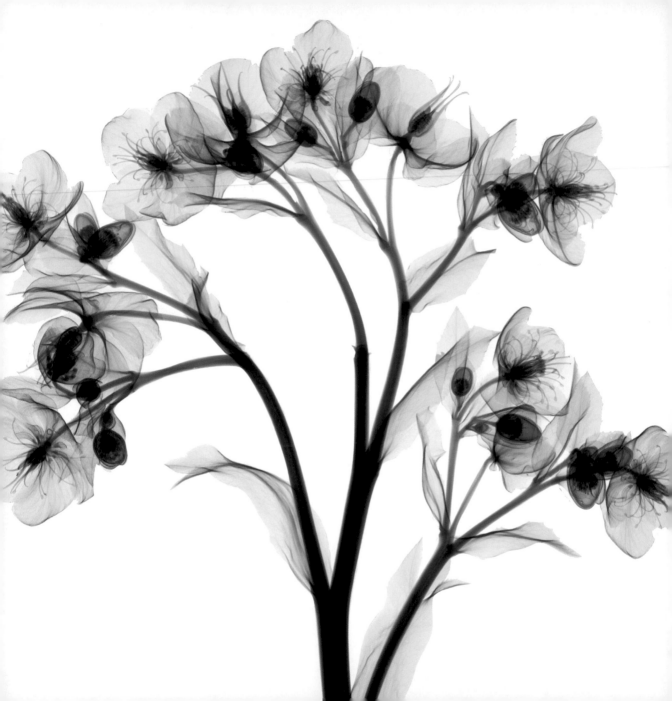

Who would have thought it possible that a tiny little flower could preoccupy a person so completely that there simply wasn't room for any other thought.

Sophie Scholl

Tulip

Perfect lover. "A declaration of love!" Flower of spring. Imagination and dreaminess.

It is said in a Persian legend that a young man, Farhad, was in love with a beautiful woman, Sharin. One day, Farhad received news that his lover was dead. In his grief, he jumped off a high cliff, and where his body landed, there the tulips first began to grow. The saddest part was that the message was sent by a jealous rival, and Sharin was actually still alive.

Hana No Monogatari

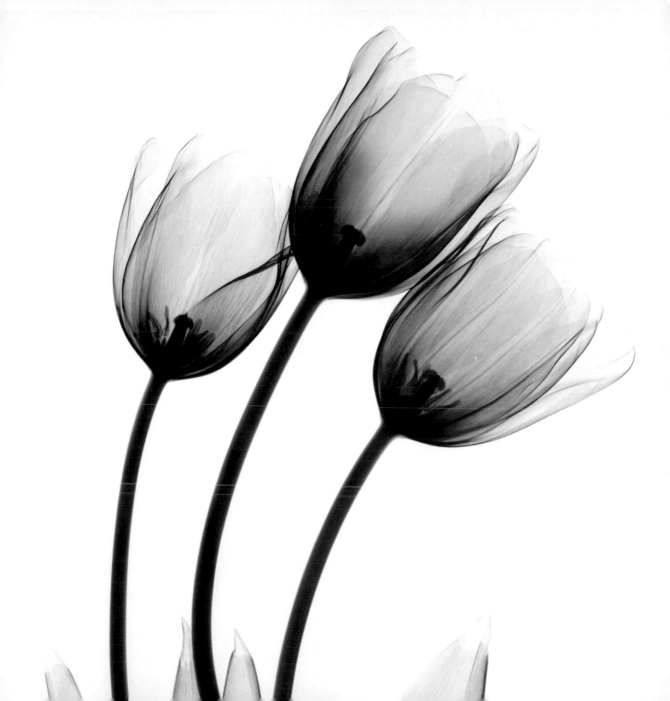

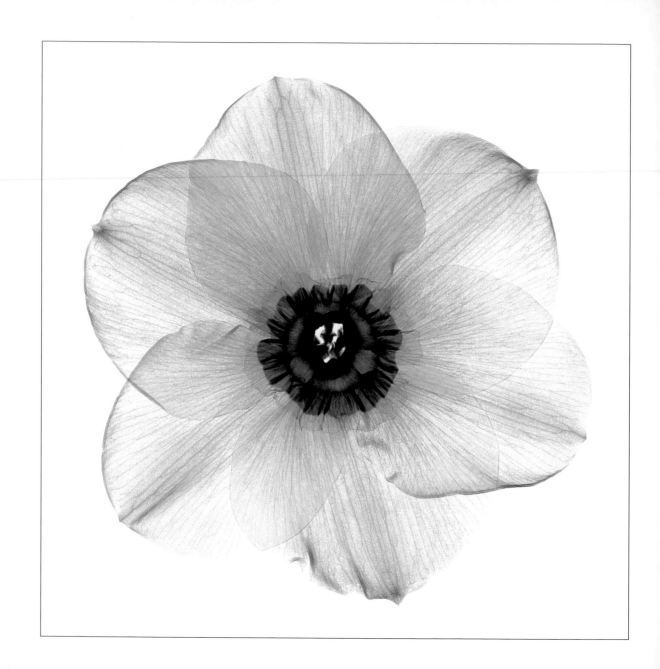

Here's flowers for you:
Hot lavender, mints, savory, marjoram,
The marigold, that goes to bed wi'the sun,
And with him rises, weeping.

<div align="right">William Shakespeare</div>

"If flowers have souls," said Undine, *"the bees, whose nurses they are, must seem to them darling children at the breast. I once fancied a paradise for the spirits of departed flowers." "They go,"* answered I," *"not into paradise, but into a middle state; the souls of lilies enter into maidens' foreheads, those of hyacinths and forget-me-nots dwell in their eyes, and those of roses in their lips."*

Jean Paul Friedrich Richter

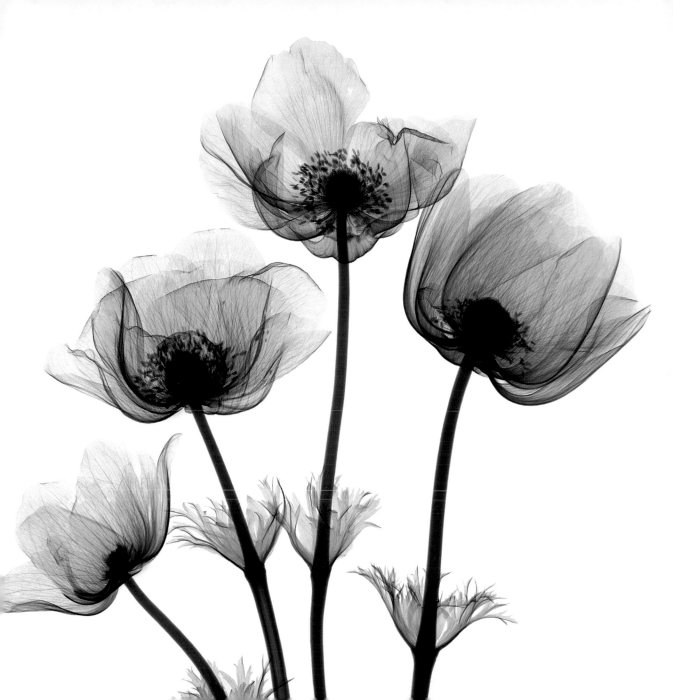

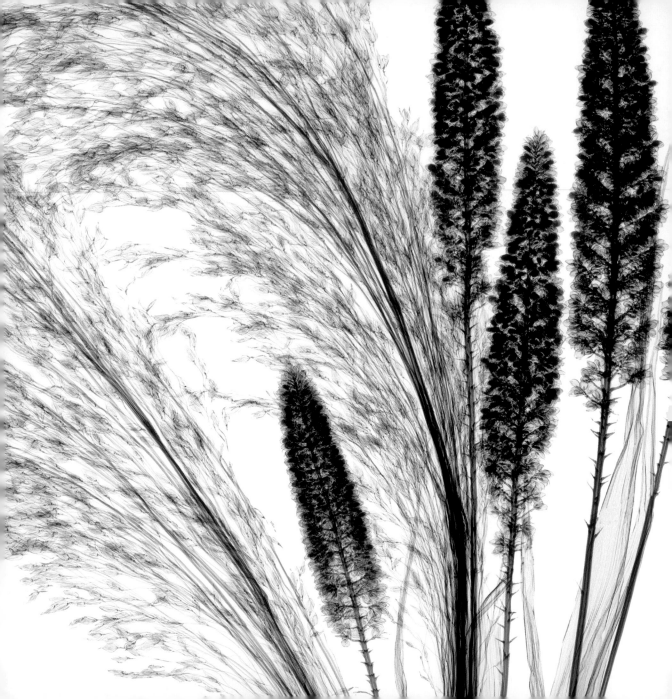

Nature knows no difference between

weeds and flowers.

Mason Cooley

The bud

stands for all things,

even for those things that

don't flower.

<div align="right">Galway Kinnell</div>

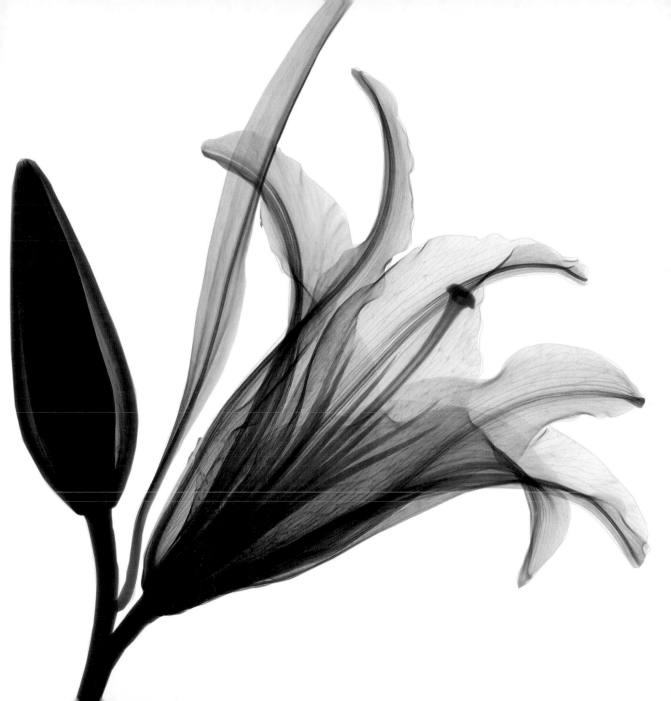

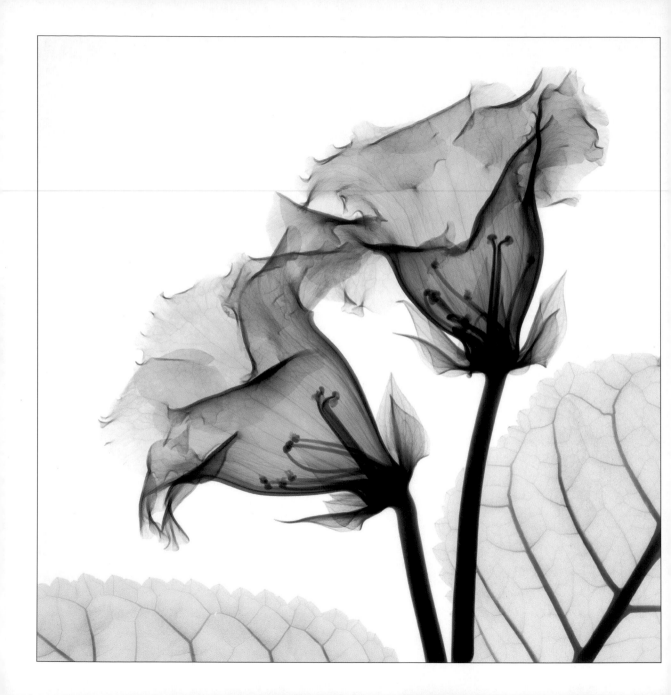

I will be the gladdest thing
Under the sun!
I will touch a hundred flowers
And not pick one.

Edna St. Vincent Millay

To see a hillside white with dogwood bloom is to know a particular ecstasy of beauty, but to walk the gray winter woods and find the buds which will resurrect that beauty in another May is to partake of continuity.

Hal Borland

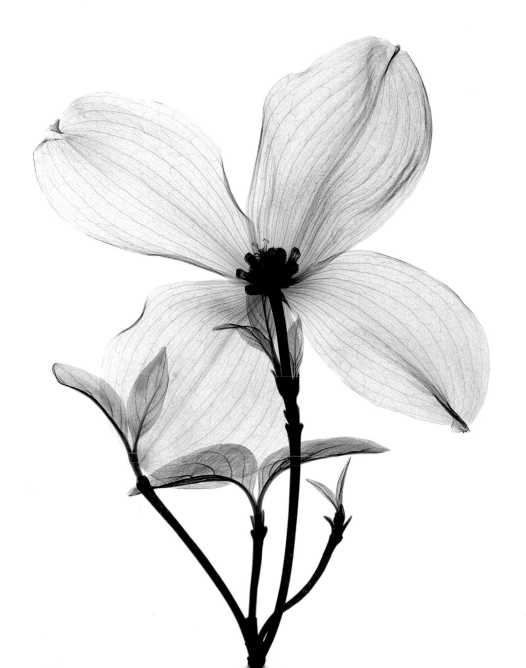

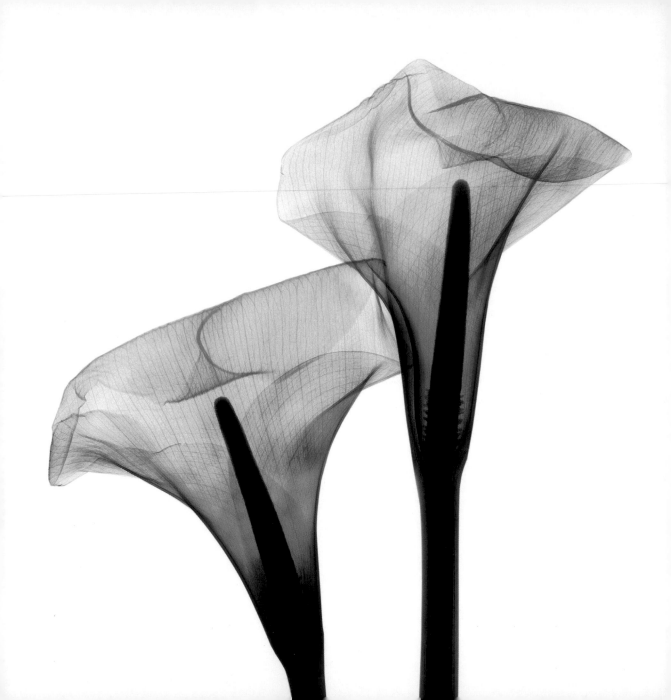

At dawn I asked the lotus: 'What is the meaning of life?'

Slowly, she opened her hand with nothing in it.

Debra Woolard Bender

The best things in life are nearest: breath in your nostrils, light in your eyes, flowers at your feet, duties at your hand, the path of right just before you. Then do not grasp at the stars, but do life's plain, common work as it comes, certain that daily duties and daily bread are the sweetest things in life.

Robert Louis Stevenson

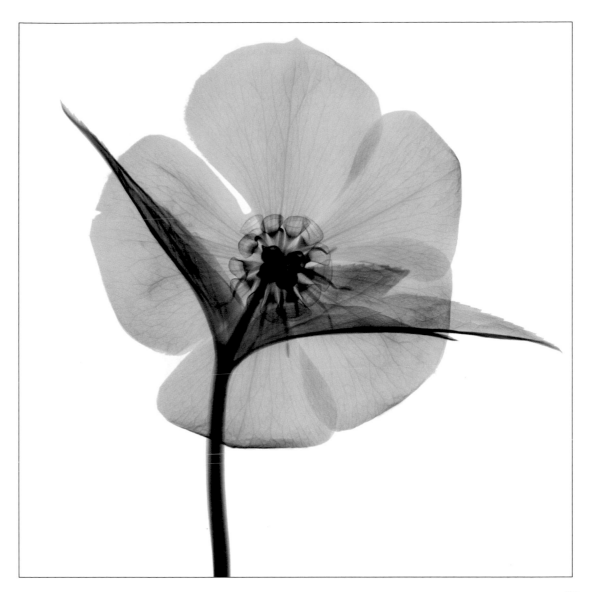

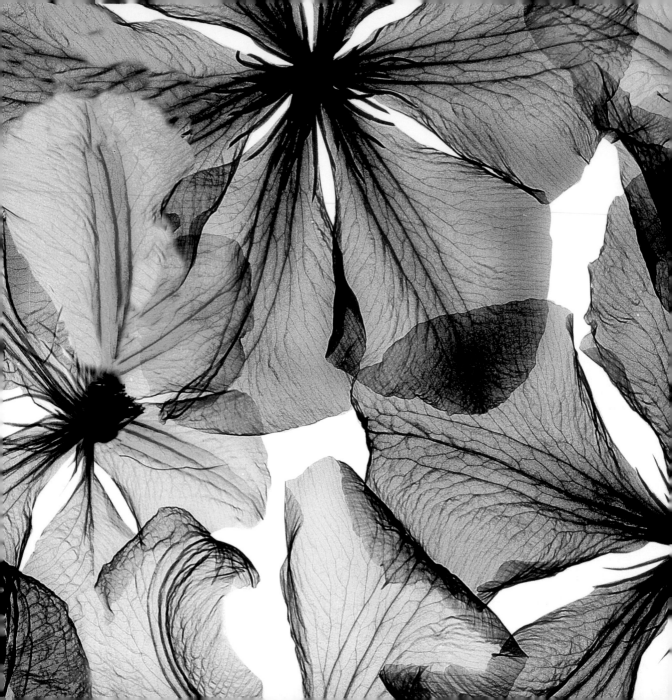

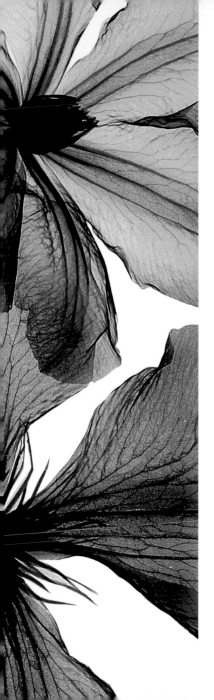

In the dooryard fronting
an old farm-house near the
white-wash'd palings,
Stands the lilac bush tall-
growing with heart-shaped
leaves of rich green,
with many a pointed blossom
rising delicate, with the
perfume strong I love,
With every leaf a miracle
— and from this bush in the
dooryard, With delicate-color'd
blossoms and heart-shaped
leaves of rich green
A sprig with its flower I break.

Walt Whitman

Flowers have

spoken to me more than I can

tell in written words. They are the hieroglyphics

of angels, loved by all for the beauty of their character

though few can decipher even fragments of

their meaning.

Lydia M. Child

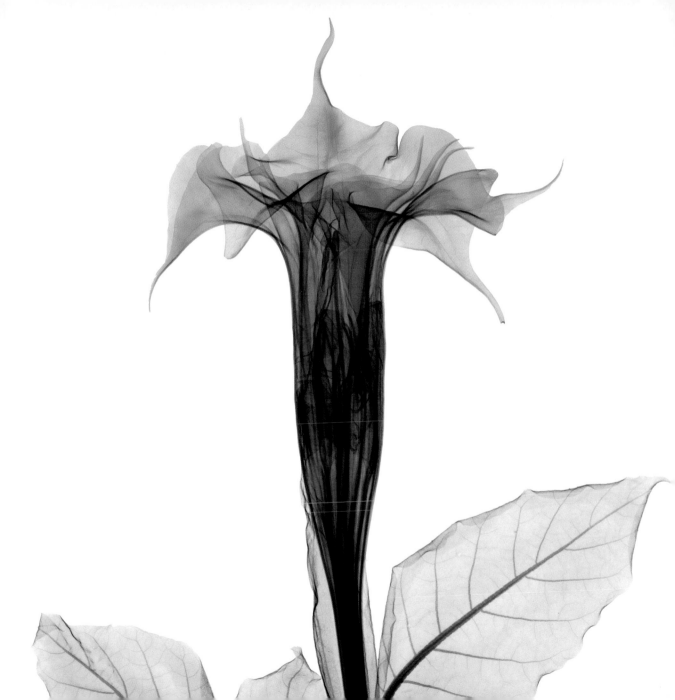

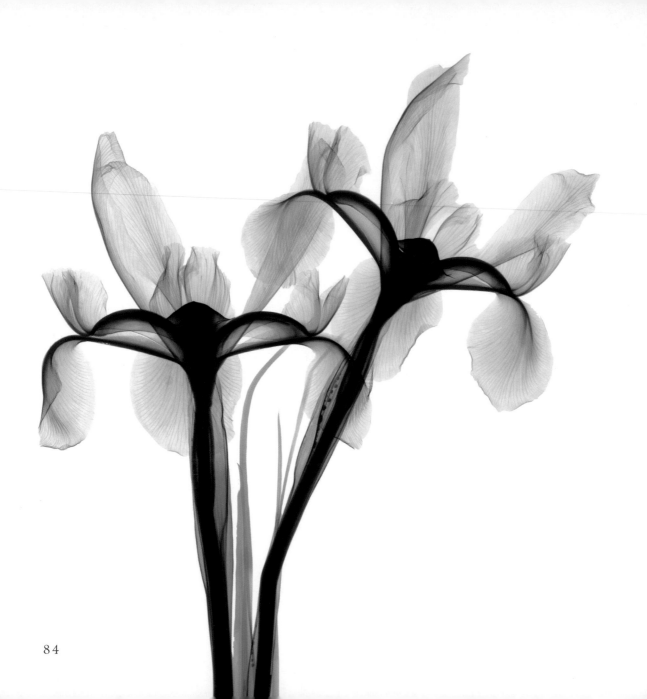

Since Iris is the Greek goddess for the *messenger of love*, her sacred flower is considered the symbol of communication and messages. Greek men would often plant an iris on the graves of their beloved women as a tribute to the goddess Iris, whose duty it was to take the souls of women to the Elysian Fields.

Hana No Monogatari

Daffodils . . . grew among the mossy stones about and above them; some rested their heads upon these stones, as on a pillow, for weariness.

Dorothy Wordsworth

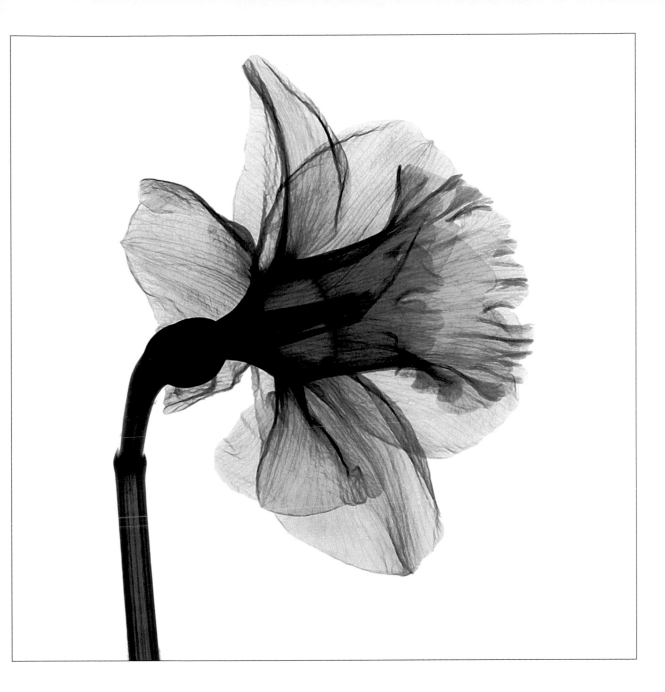

When I go into the garden with a spade,
and dig a bed, I feel such an exhilaration
and health that I discover that I have been
defrauding myself all this time in letting others
do for me what I should have done with my own hands.

Ralph Waldo Emerson

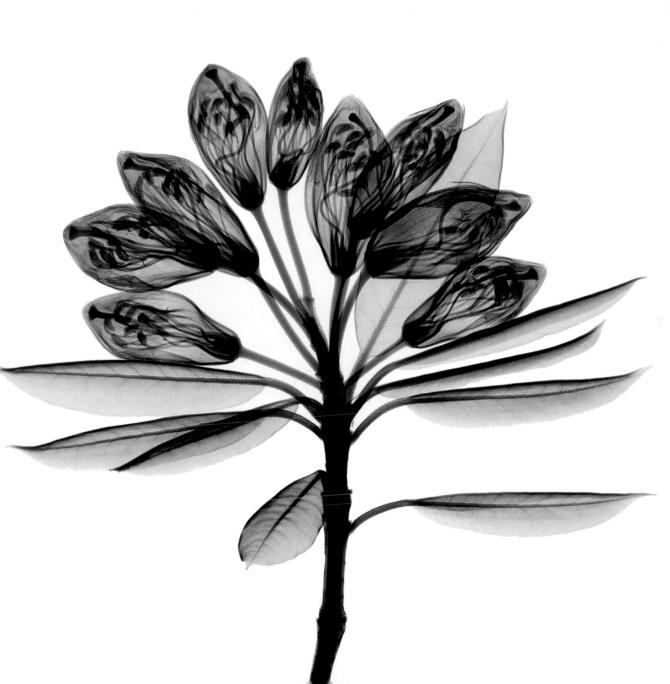

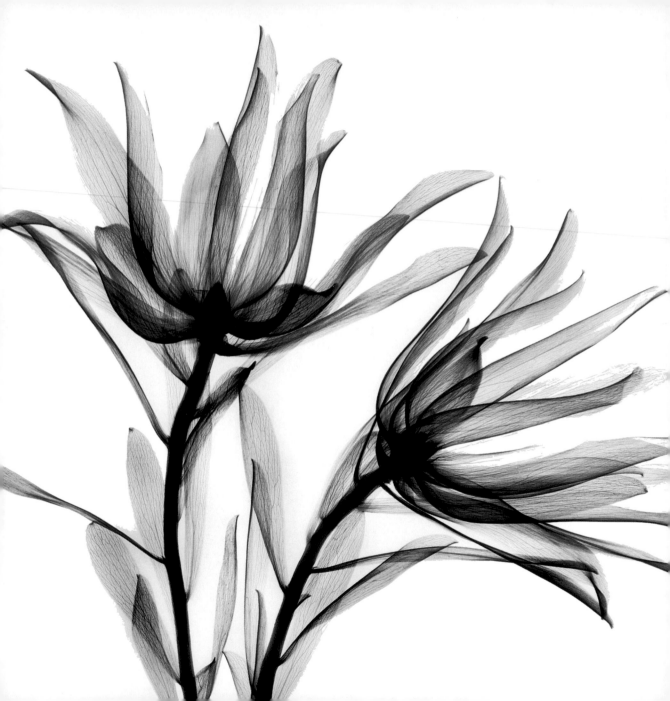

I am inclined to think that the flowers we most love

are those we knew when we were very young, when our

senses were most acute to color and to smell, and our

natures most lyrical.

Dorothy Thompson

Love is

the flower of life, and

blossoms unexpectedly and with-

out law, and must be plucked where it is

found, and enjoyed for the brief hour of its duration.

D. H. Lawrence

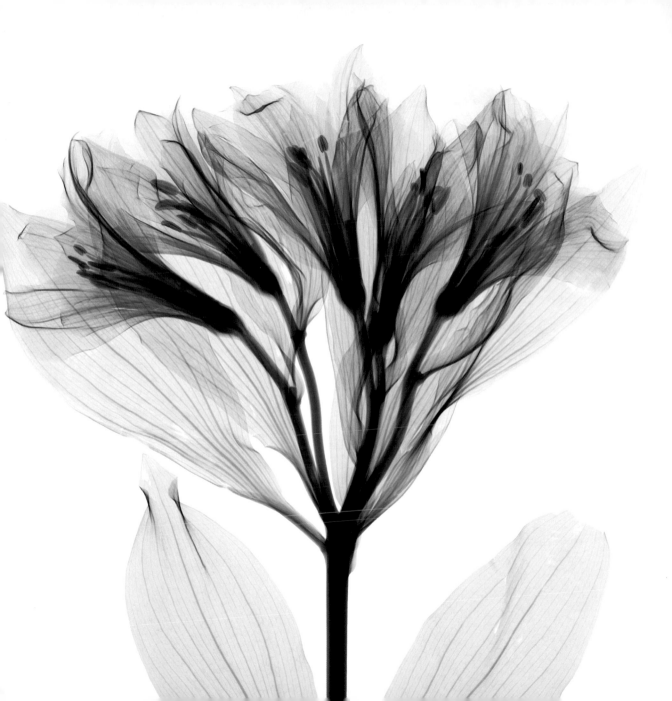

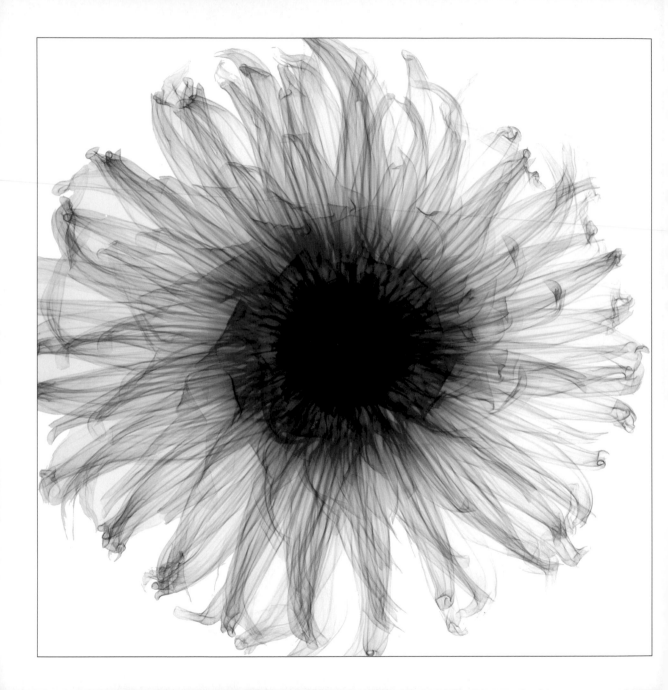

He who is born with a silver spoon in his mouth is generally considered a fortunate person, but his good fortune is small compared to that of the happy mortal who enters this world with a passion for flowers in his soul.

Celia Thaxter

TEXT CREDITS

p. 4, Koran; p. 7 © May Sarton, *Plant Dreaming Deep;* p. 8 Gautama Siddharta; p. 10 © Diane Ackerman; p. 13 Lucy Maud Montgomery, *Anne's House of Dreams*; p. 15 Henry David Thoreau, from *The Allegash and East Branch*; p. 16 Claude Monet; p. 19 James Russell Lowell; p. 20 Clare Leighton, *Four Hedges, A Gardener's Chronicle*; p. 23 Albert Schweitzer; p. 24 Saint Therese of Lisieux; p. 27 © Hana No Monogatari, *Flower Myths*; p. 28 Georgia O'Keefe; p. 31 George Eliot, *Roses*; p. 32 Frank Lloyd Wright; p. 34 Father George Schoener *The Importance and Fundamental Principles of Plant Breeding*; p. 37 © Savannah Skye, *The Brillance of Flowers;* p. 38 Ouida (pseudonym of Marie Louise de la Ramee); p. 41 © Duane Michals, from *The Vanishing Act*; p. 42 *Valentine's Day Love Traditions*; p. 45 J. R. R. Tolkien; p. 46 © Nancy Goodwin, *Cyclamen*; p. 48 Alfred Tennyson. from *Maud*; p. 51 Nathaniel Parker Willis; p. 52 © Lewis Thompson; p. 55 Theodore Parker; p. 58 Francis Thompson; p. 61 © Sophie Scholl; p. 62 © Hana No Monogatari, *Flower Myths*; p. 65 William Shakespeare; p. 66 Jean Paul Friedrich Richter; p. 69 Mason Cooley; p. 70 © Galway Kinnell; p. 73 Edna St. Vincent Millay, from *Afternoon on a Hill*; p. 74 © Hal Borland; p. 77 © Debra Woolard Bender, *Paper Lanterns*; p. 78 Robert Louis Stevenson; p. 81 Walt Whitman; p. 82 Lydia M. Child; p. 85 © Hana No Monogatari, *Flower Myths*; p. 86 © Dorothy Wordsworth, *Journals of Dorothy Wordsworth*; p. 88 Ralph Waldo Emerson; p. 91 © Dorothy Thompson, *The Courage to Be Happy*; p. 92 D. H. Lawrence; p. 94 Celia Thaxter.

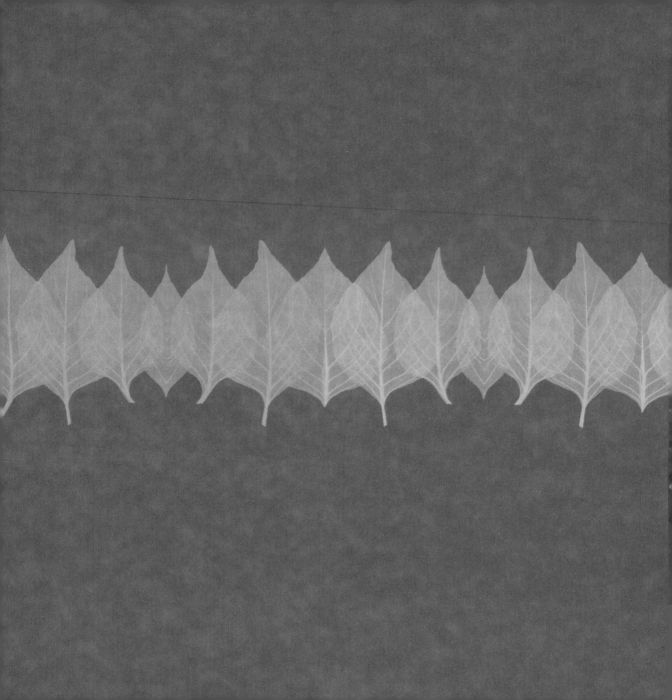